T0276656

USE YOUR IMAGINATION. TRAIN YOUR BRAIN AND HAVE FUN!

BIS Publishers
Borneostraat 80-A
1094 CP Amsterdam
The Netherlands
T +31 (0)20 515 02 30
bis@bispublishers.com
www.bispublishers.com

ISBN 978 90 6369 612 2

Copyright © 2021 Dorte Nielsen, Katrine Granholm
and BIS Publishers.

The copyright for the individual exercises is held by
Dorte Nielsen and Katrine Granholm. Printed here
with permission.

All rights reserved. No part of this publication may
be reproduced or transmitted in any form or by
any means, electronic or mechanical, including
photocopy, recording or any information storage
and retrieval system, without permission in writing
from the copyright owners.

Every reasonable attempt has been made to identify
owners of copyright. Any errors or omissions
brought to the publisher's attention will be
corrected in subsequent editions.

Based on theory by Dorte Nielsen.
Concept: Dorte Nielsen and Katrine Granholm.
Design: Katrine Granholm and Dorte Nielsen.

Set in Gotham.
www.creativethinker.com

CREATIVE THINKER'S

Dorte Nielsen &
Katrine Granholm

RETHINK BOOK

HIGHLY CREATIVE PEOPLE ARE GOOD AT SEEING CONNECTIONS

BY ENHANCING YOUR ABILITY TO SEE CONNECTIONS, YOU CAN ENHANCE YOUR CREATIVITY.

This book trains your ability to make new connections and come up with original ideas. Making connections is the underlying mechanism that helps us to think creatively.

Just like you can train your muscles, you can train your brain. The better you are at making connections, the better a creative thinker you become.

Think and think again. Strengthen your ability to make many ideas. The Rethink Book helps you to see more connections and go further.

Enjoy!

1. Rethink the screws

Train your ability to think creatively by looking at things in new ways. Start with these screws. What else might they be? Challenge your imagination to go beyond the most obvious ideas. Draw your ideas by adding to the screws on these pages

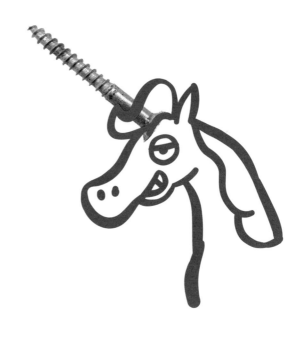

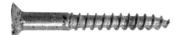

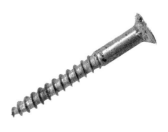

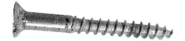

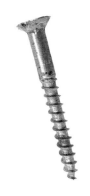

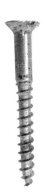

2. Rethink the bottle caps

Train your ability to make new connections by thinking of new ways to look at bottle caps. Challenge your imagination to go beyond your first ideas. Seek new, fun, useful, or crazy ideas. Draw your thoughts by adding to the bottle caps

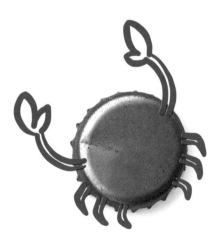

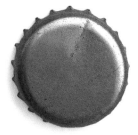

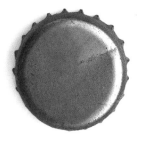

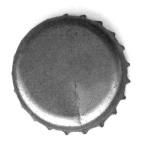

3. Rethink the nutcrackers

Think of new ways of looking at nutcrackers. Make new connections. Draw your ideas by adding to the pictures on these pages.

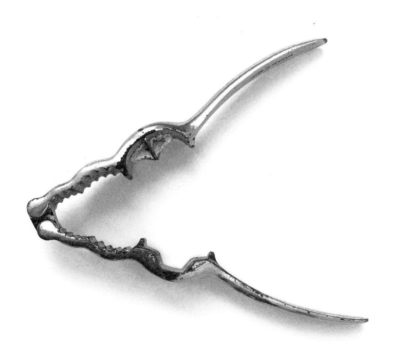

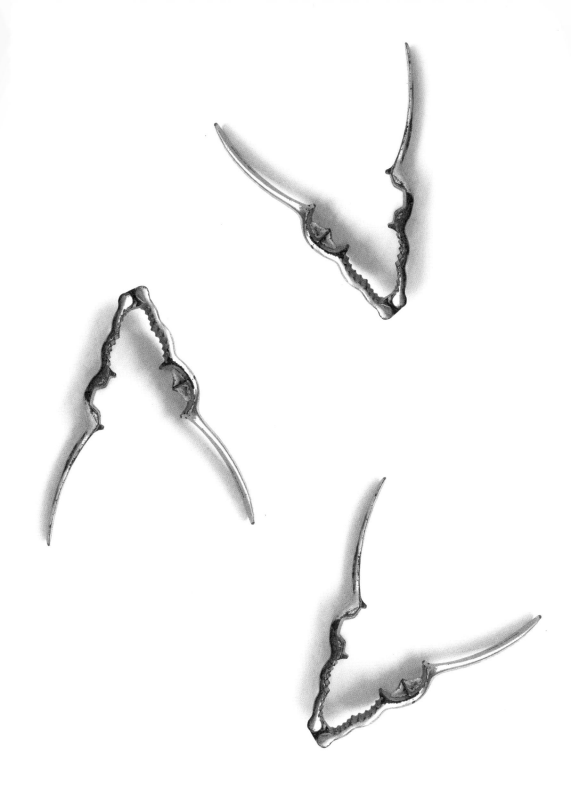

4. Rethink the matchsticks

It's good to practise having more than one idea. How many ideas can you make out of a matchstick?

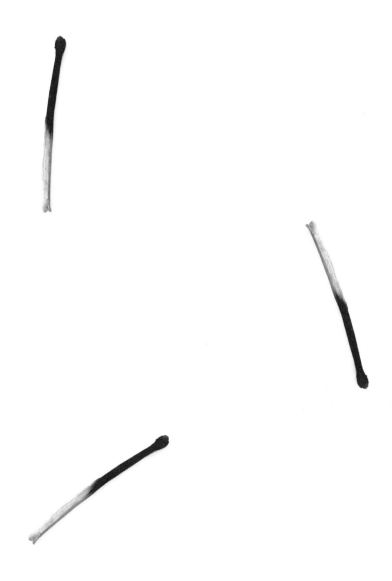

WHAT ELSE CAN YOU MAKE?

5. Rethink the decorations

It time to reinvent your Christmas decorations and make them into something completely different. Go beyond the most obvious ideas. Seek fun, wacky, or different thoughts. They can be sensible or crazy, useful or useless. Draw your ideas by adding to the pictures.

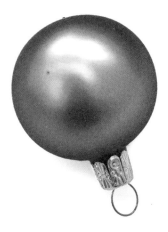

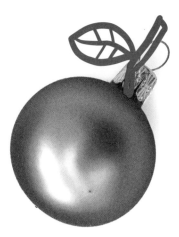

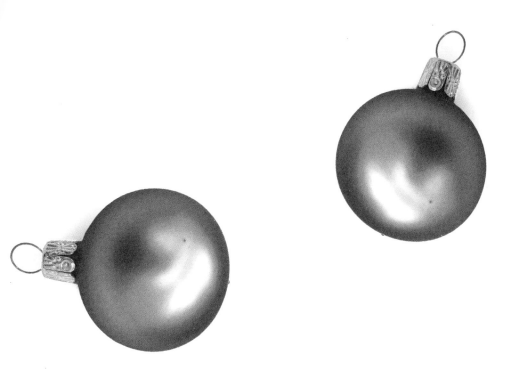
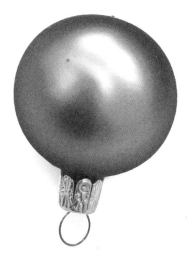

6. Rethink the piping cones

What else can you make out of piping cones? Draw your ideas.

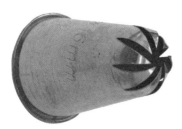

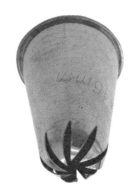

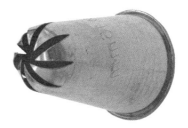

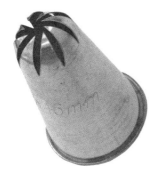

HAVE
FUN!

7. Rethink the darning tools

A darning tool is use for reparing socks. What else might it be? Use your imagination and draw your ideas.

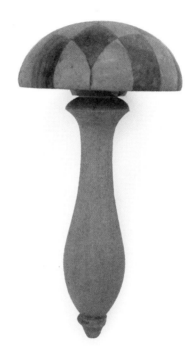

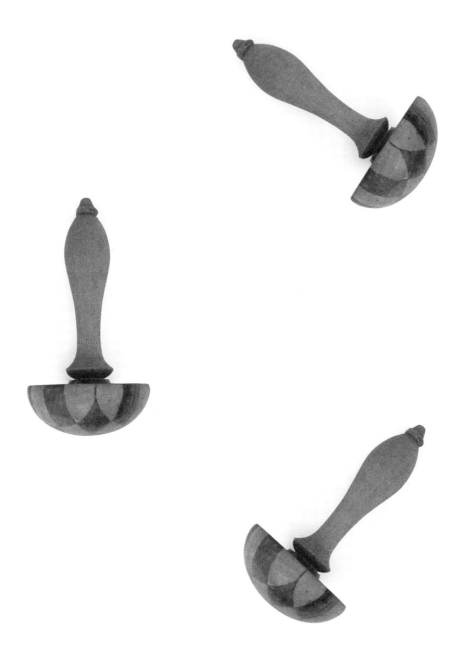

8. Rethink the pine cones

Train your mind to make visual connections. Look at the images below. What new visual connections can you make? Think and sketch your ideas.

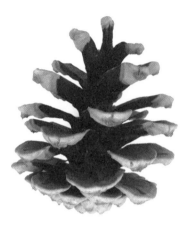

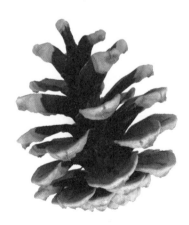

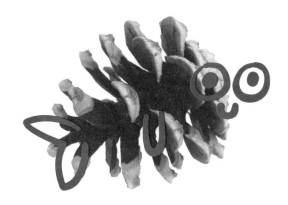

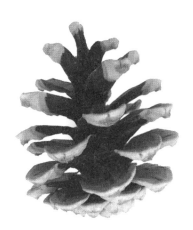

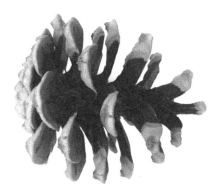

9. Rethink the safety pins

Coming up with alternative way to look at an object can help you to stretch your thinking and train your ability to make new connections. Challenge yourself to push your thinking further than the most obvious ideas. Go for quantity and draw your ideas around the pictures.

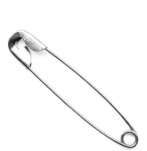

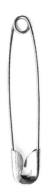

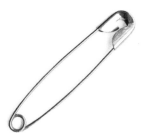

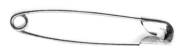

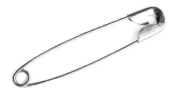
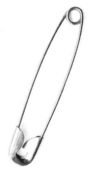
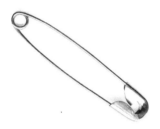
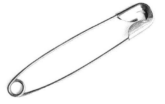

10. Rethink the berries

Look at the berries. What else do you see? Challenge yourself to think further.

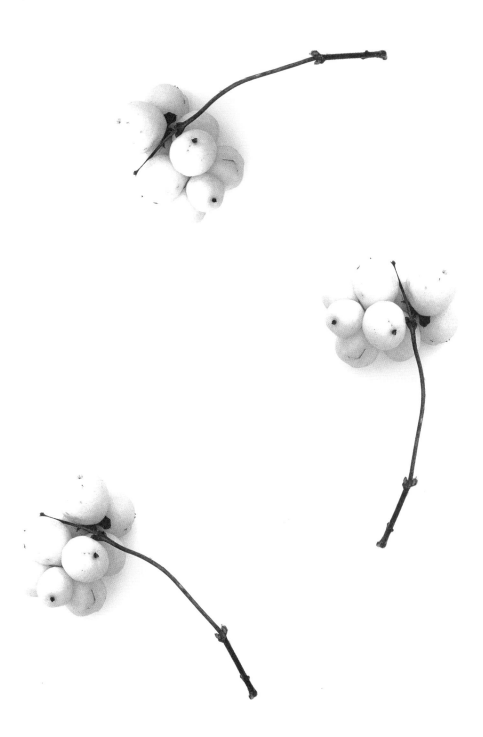

11. Rethink the pills

Be flexible in your thinking. Try to think of ideas from very different areas: Transport, Animals, Food or Sports. Draw your ideas around each of the pills. Don't worry about making mistakes, just go for quantity.

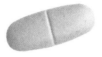

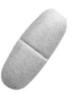

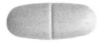

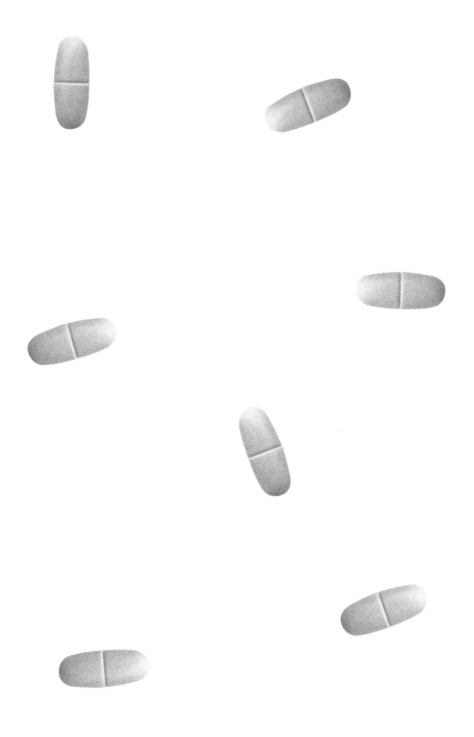

12. Rethink the mirror balls

Train your ability to make visual connections. Look carefully at the shape and rethink the mirror balls.

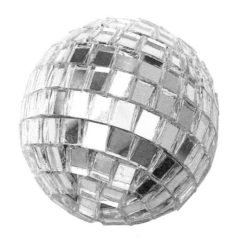

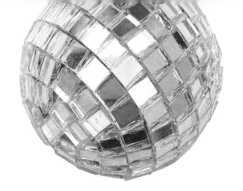

LET'S GO GO!

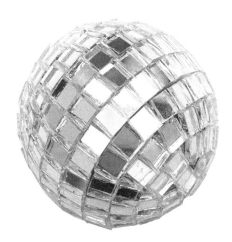

13. Rethink the ring pulls

Use this unusual shape to make some unusual ideas. What could a ring pull become? Generate lots of ides on the right and then pick your favorite and draw it on the left.

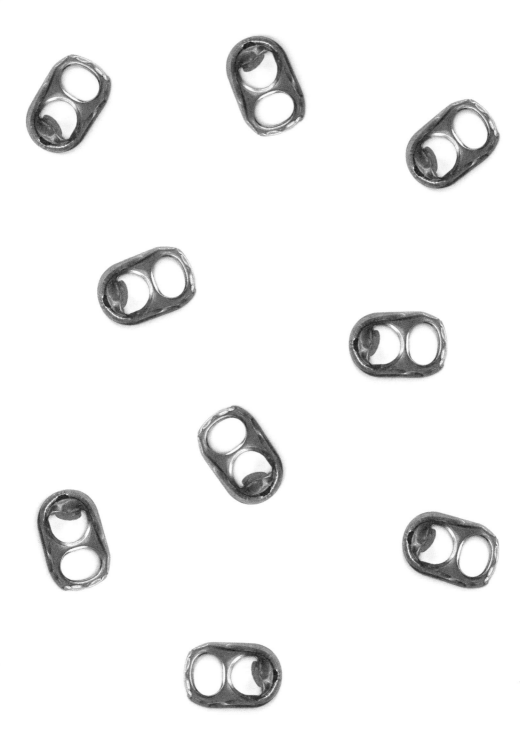

14. Rethink the string

Look at the shapes created by the string. Notice the negative space created by the string by looking at the white background rather than the string. Rethink the shapes and add your ideas.

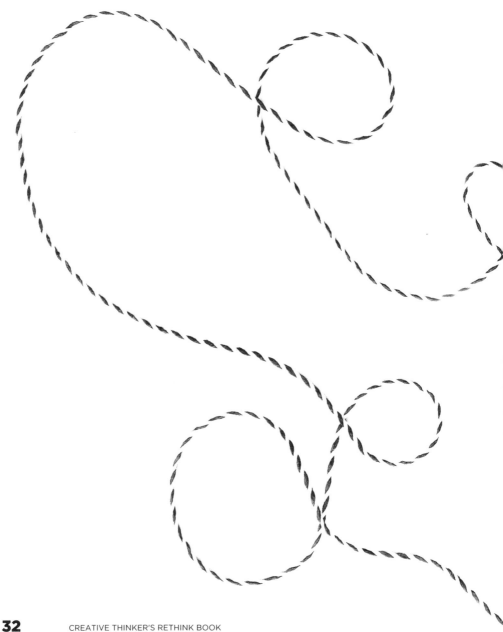

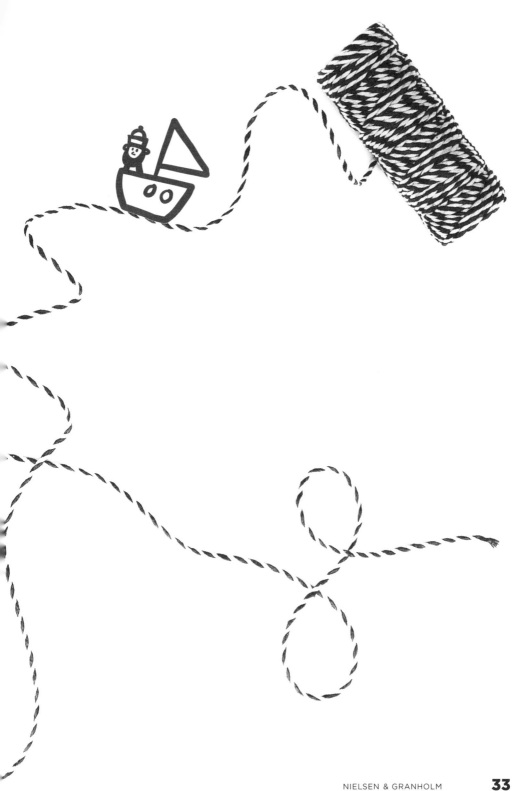

15. Rethink the pins

Train your brain to make new connections by thinking of alternative uses for pins. Go beyond the most obvious ideas. Seek new, fun, wacky, or different thoughts. They can be sensible or crazy, useful or useless, as long as they are new alternative uses. Draw your ideas by adding to the pins.

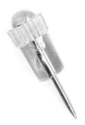

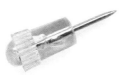

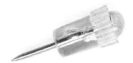

KEEP GOING!

16. Rethink the scissors

What else can you make out of a pair of scissors?

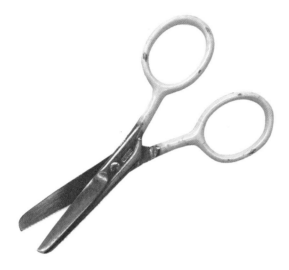

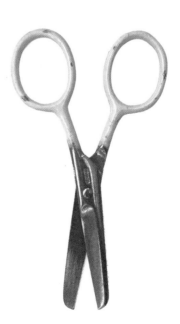

CREATIVE THINKER'S RETHINK BOOK

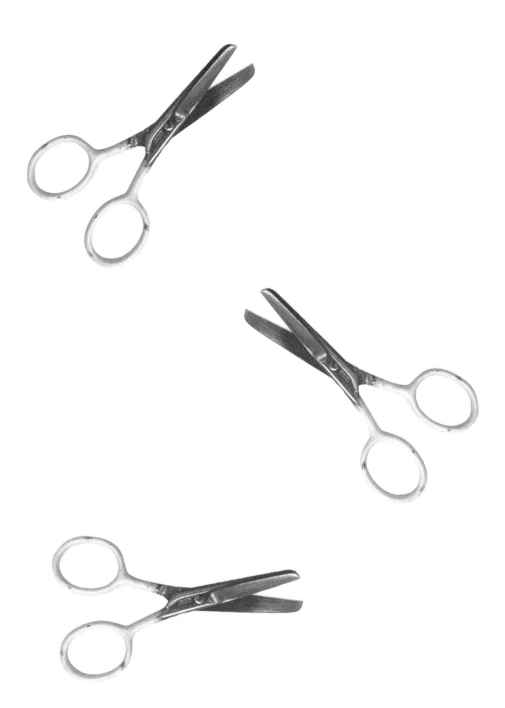

17. Rethink the garlic

Use the garlic to create new ideas. Try to look at them in new ways. Challenge your imagination to go beyond the most obvious ideas. Draw your thoughts by adding to the garlic.

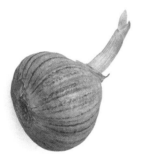

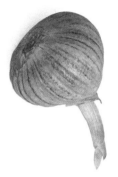

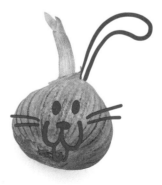

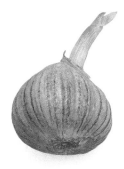

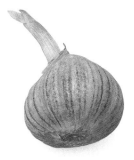

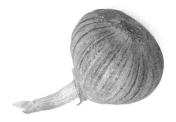

18. Rethink the ruler

Try to look at the ruler in new ways. What do you see?

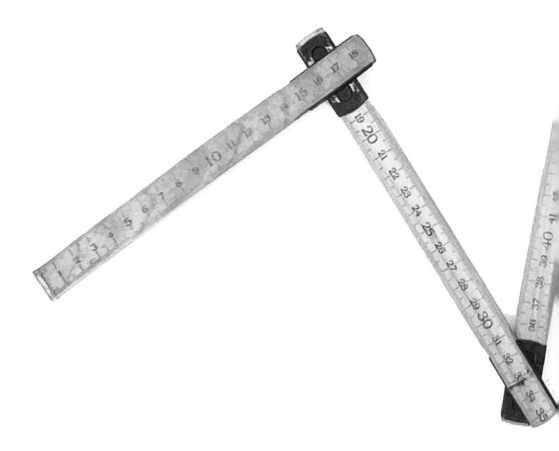

19. Rethink the popcorn

Challenge your imagination. Think of how you can rethink popcorn.

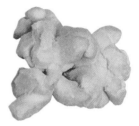

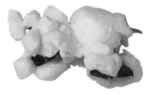

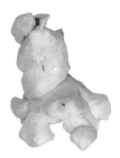

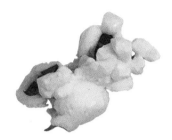

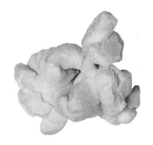

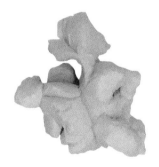

20. Rethink the fans

Challenge yourself. Rethink the fans. Draw your ideas.

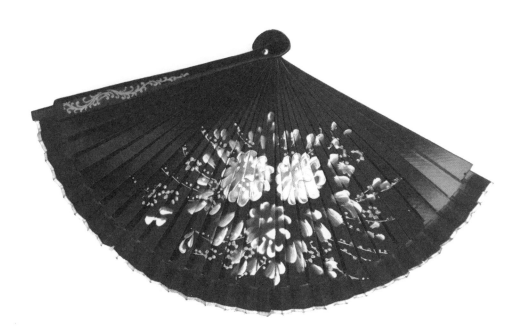

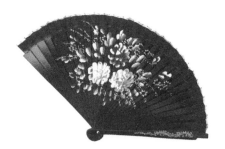

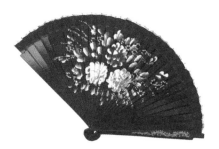

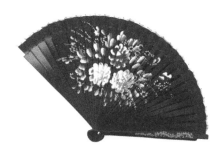

21. Rethink the rings

Draw your ideas around the rings. Try to go for fun and surprising solutions.

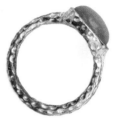

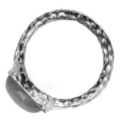

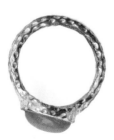

22. Rethink the spanners

Now try with spanners! What can you make using a spanner? Seek fun and unusual ideas.

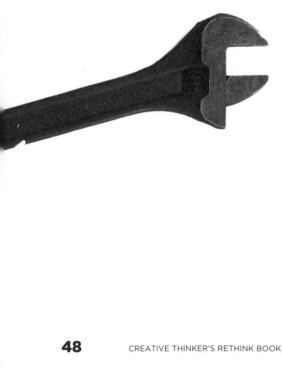

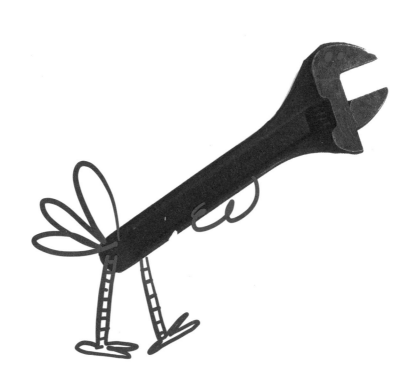

23. Rethink the toilet rolls

Make new and wonderfully ideas. Nothing is too silly. Just have fun!

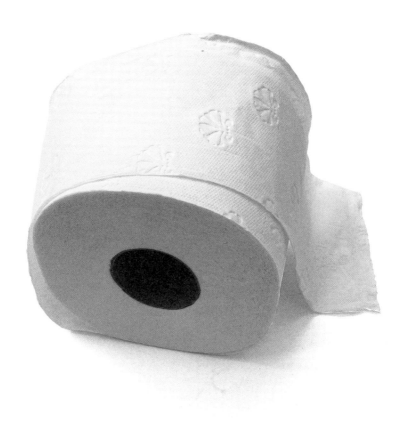

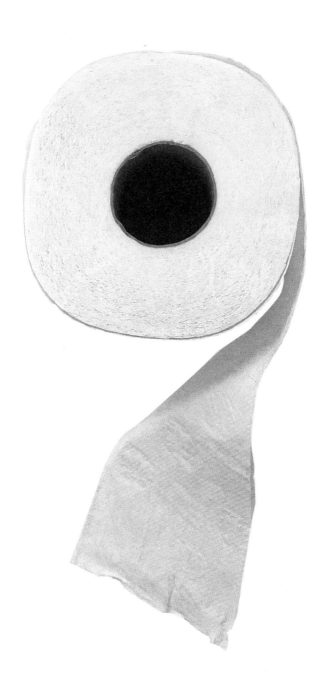

24. Rethink the batteries

Think of how many different kinds of ideas you can create using a battery. Draw your best ideas.

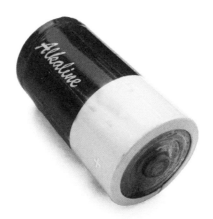

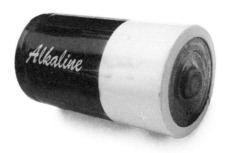

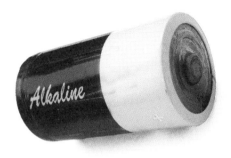

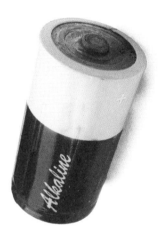

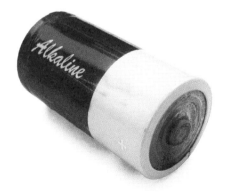

25. Rethink the cereal

Why not? Let's think differently. What if all your ideas for this exercise only had to do with transport? Just try! Having a theme in mind helps you to make new connections. Rethink the cereal and draw your ideas around the pictures.

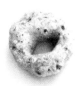
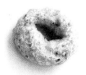
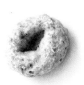
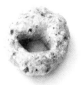
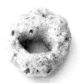

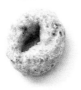
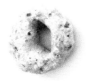
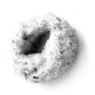
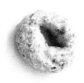
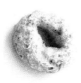
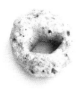
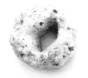

26. Rethink the pencils

Go further. Try to come up with ideas you haven't thought of before in the previous exercises.

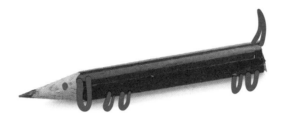

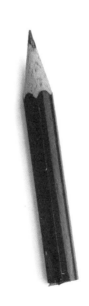

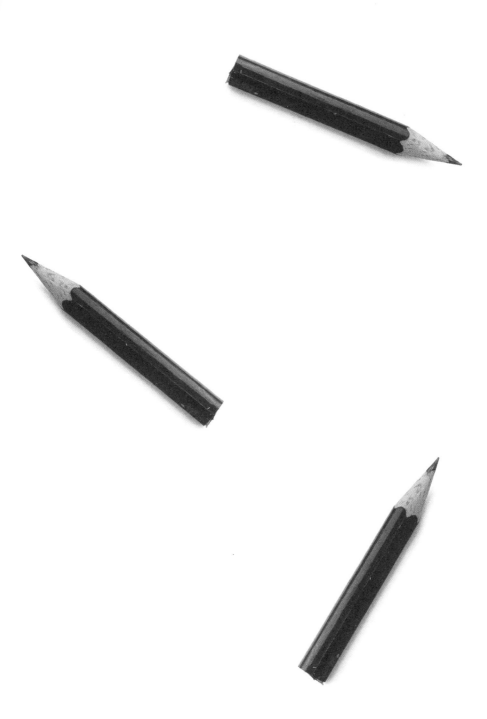

27. Rethink the oranges

Now you are half way. Enjoy the oranges. Keep going! Train your brain to make visual connections. Rethink the oranges!

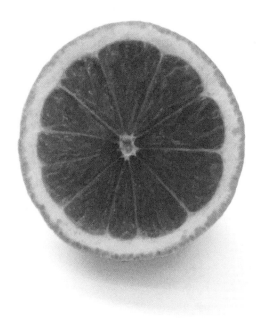

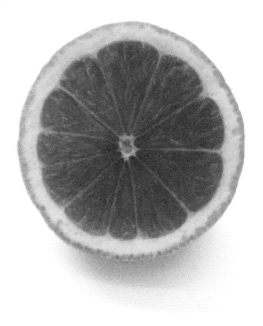
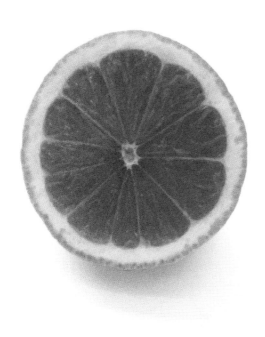

28. Rethink the jars

Train your ability to make new connections by thinking of new senarios for these jars. What might be in them? What might the story be?

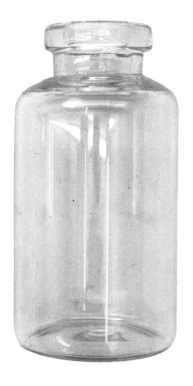

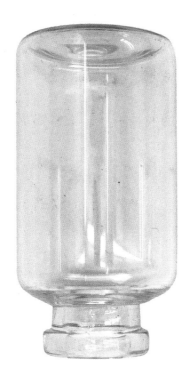

29. Rethink the forks

Thinking of alternative uses for a fork trains your brain to make new connections. Stretch your imagination. Stretch your thinking beyond the most obvious uses. Think of the fork outside of its usual context. Add your ideas to the forks on the following pages.

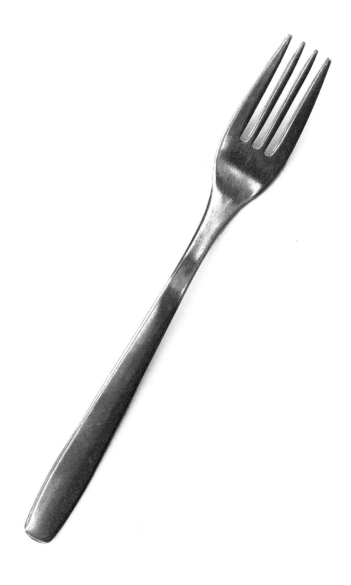

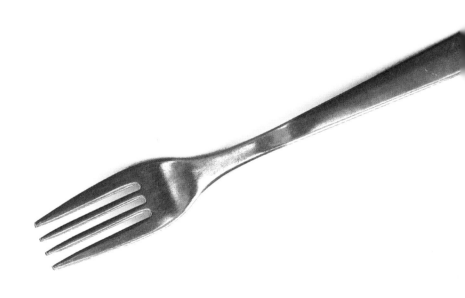

30. Rethink the nuts

Keep practicing. The more you practice the better you become. If you are running dry for ideas try to look around you for inspiration.

31. Rethink the puzzles

Start by looking at the shapes. What else might they be?

32. Rethink the hairpins

Make new, wonderfully and crazy ideas. They can be fun, silly, useful or unusual. Rethink the hairpins. Draw your ideas.

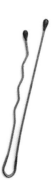

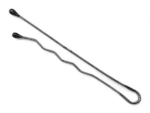

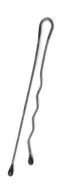

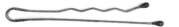

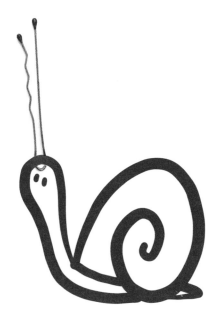

33. Rethink the candles

Think of how many different kinds of ideas you can create using a candle. Draw your best ideas.

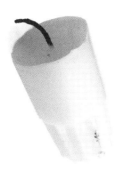

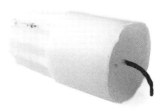

34. Rethink the nuts

Think of as many uses for nuts as you possibly can. Go for quantity. Seek new and unusual ideas. Defer judgement. Write or draw all the ideas that come to you around the nuts.

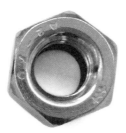

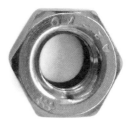

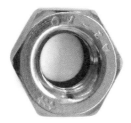
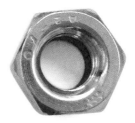
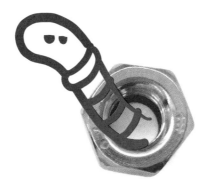

35. Rethink the whisks

Look at the each of the whisks and sketch all the ideas that comes to you.

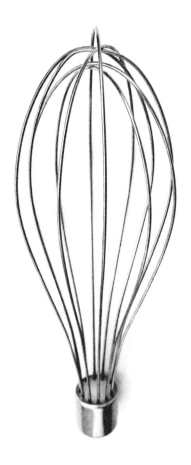

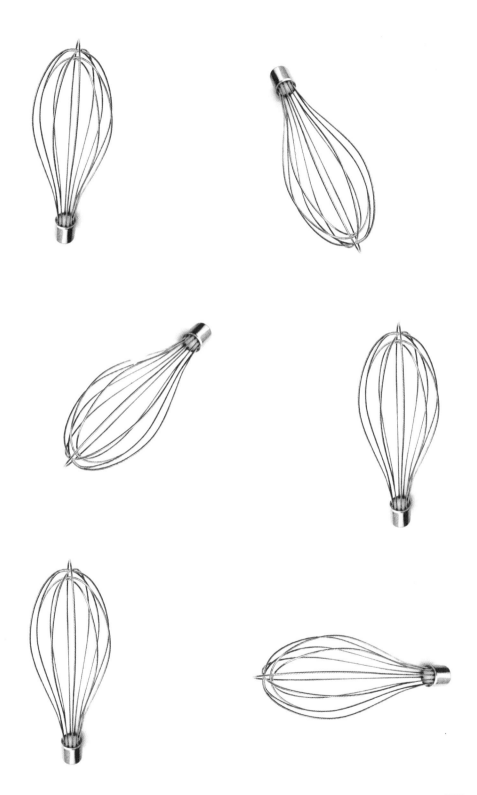

36. Rethink the keys

Start by looking at the shapes. What else might they be?

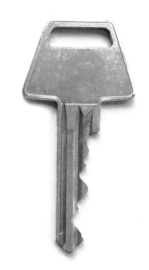

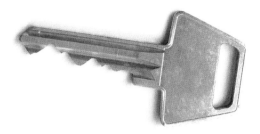

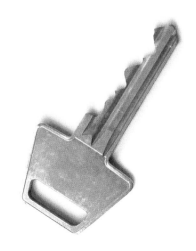

37. Rethink the brushes

Think of as many alternative ways to use a brush as you can. Draw your best ideas.

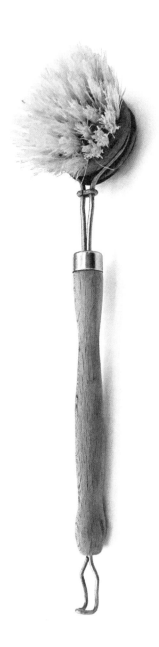

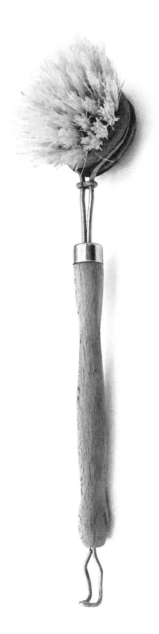

38. Rethink the donuts

What do you get when you rethink the donuts?

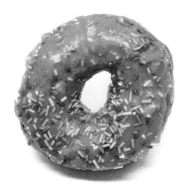

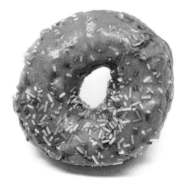

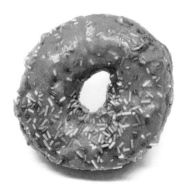

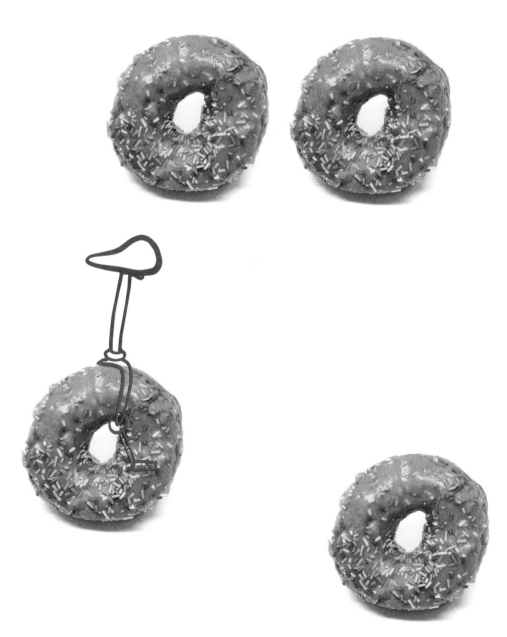

39. Rethink the twigs

Challenge yourself. Rethink the twigs. Make new and wonderful ideas.

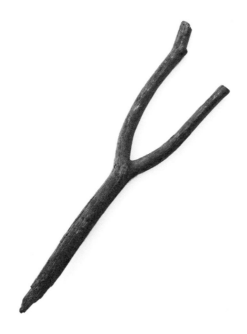

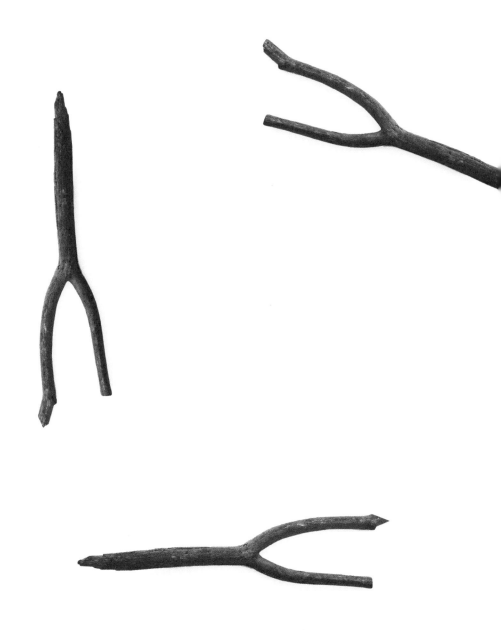

40. Rethink the pool balls

Go further. Try to come up with ideas you haven't thought of before in the previous exercises. Draw your ideas.

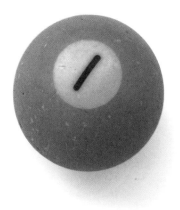

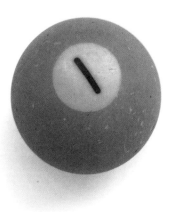

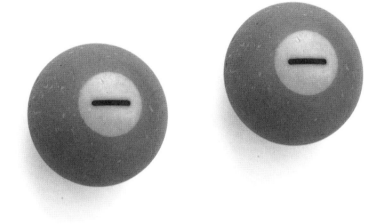
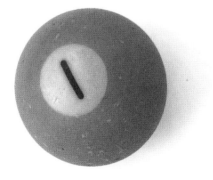

41. Rethink the leaks

Keep going! Train your brain to make visual connections. Rethink the leaks.

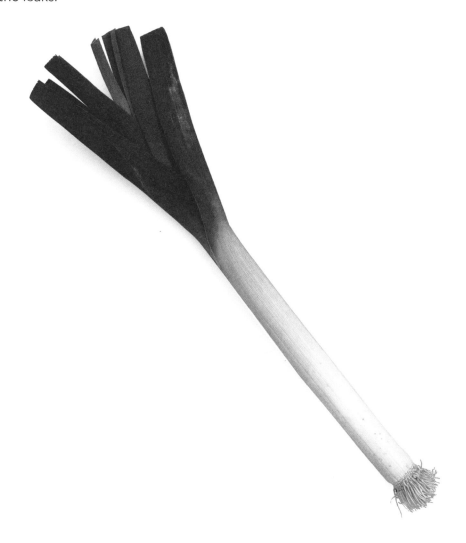

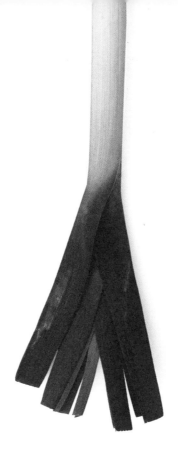

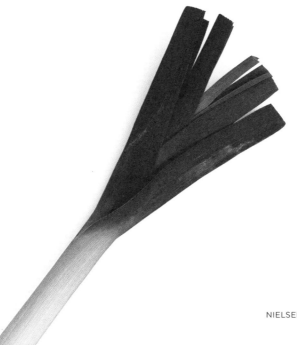

42. Rethink the cartons

Use the cartons to create new ideas. Try to look at them in new ways. Challenge your imagination to go beyond the most obvious ideas. Draw your thoughts by adding to the cartons.

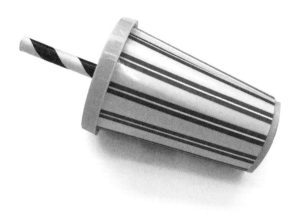

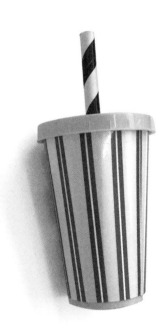

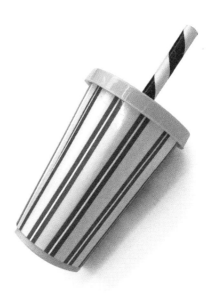
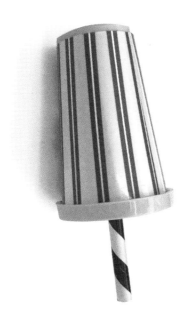

43. Rethink the streamer

Challenge your imagination. Think of how you can rethink the streamer. Draw your third idea. Don't just go for the first one.

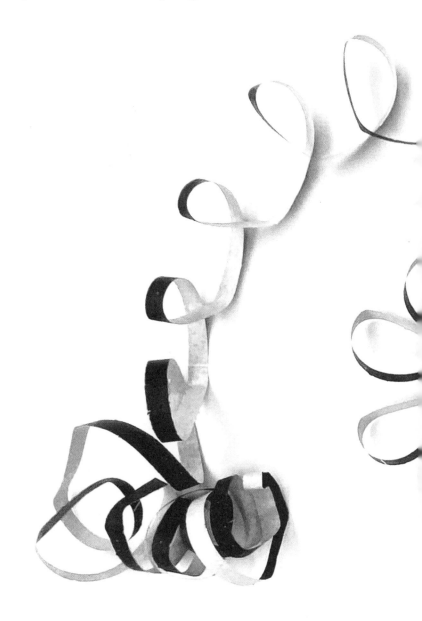

HAVE FUN!

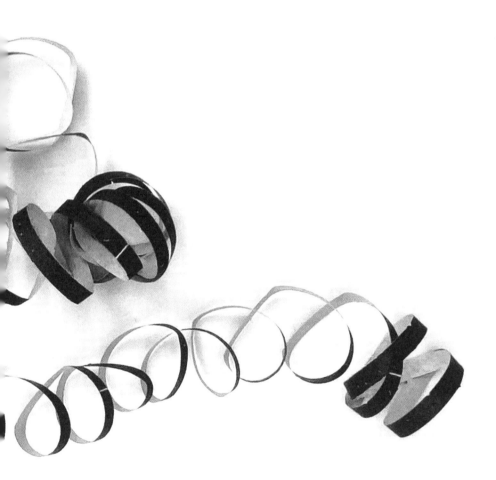

44. Rethink the candy

Train your ability to think creatively by thinking of new ways to look at candy. Challenge your imagination to go beyond the most obvious ideas. Draw your thoughts by adding to the candy on these pages.

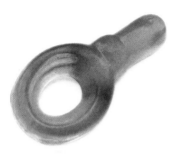

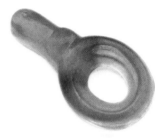

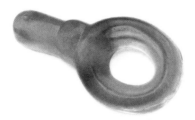

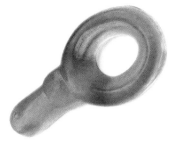
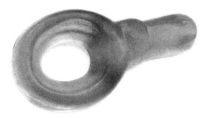
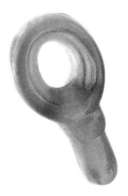

45. Rethink the sponges

What else can you make out of a sponge?

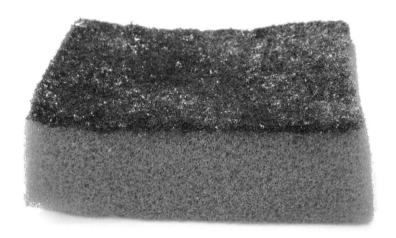

CREATIVE THINKER'S RETHINK BOOK

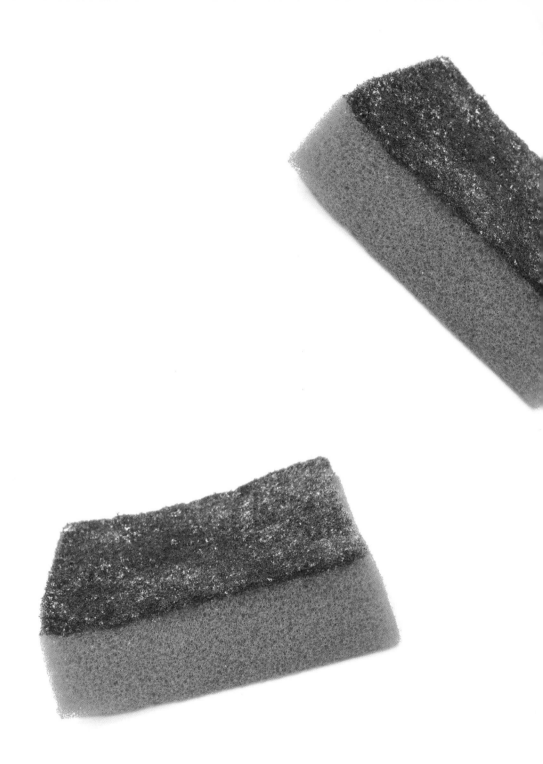

46. Rethink the pen tops

Think of how many different kinds of ideas you can create with pen tops. Draw your best ideas.

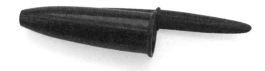

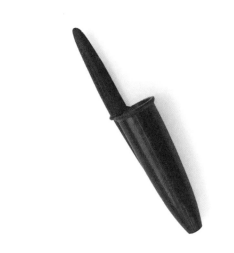

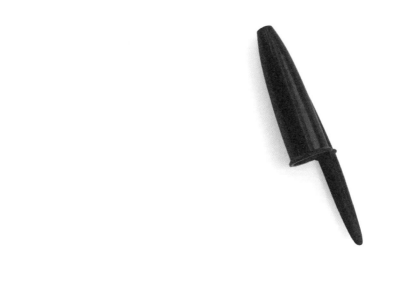
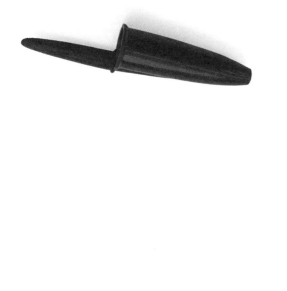
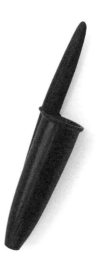

47. Rethink the trafic cones

Think of as many different ways as you can to use trafic cones. Seek new and different ideas. Draw your ideas around the cones.

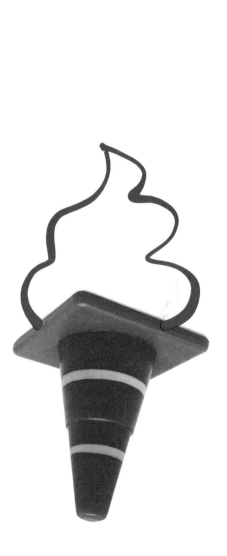

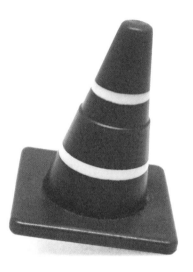

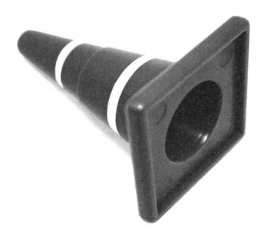

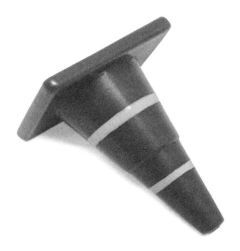

48. Rethink the spoons

What ideas come to you, when you rethink this unusual spoon?
Draw your ideas.

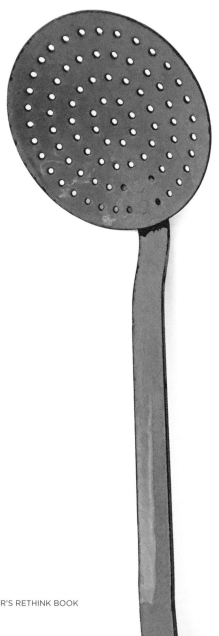

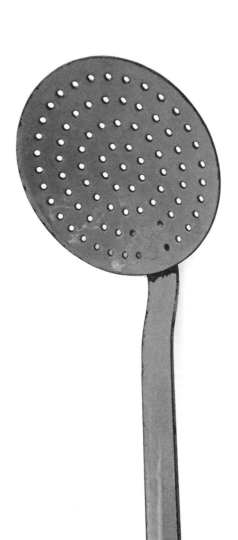

49. Rethink the buttons

Think of visual connections. Draw your ideas by adding to the buttons on these pages.

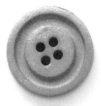
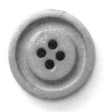
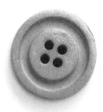
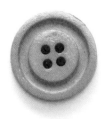

50. Rethink the protractors

Use your imagination to go beyond your first ideas. Seek new and alternative ideas. Draw your ideas by adding to the protractors.

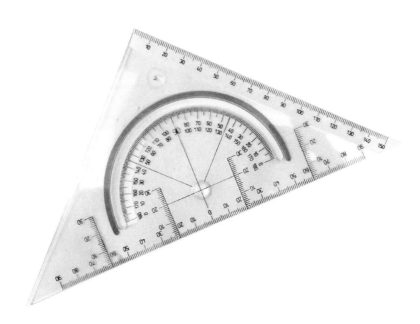

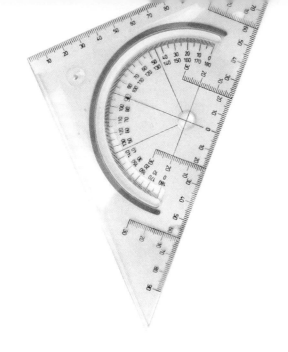

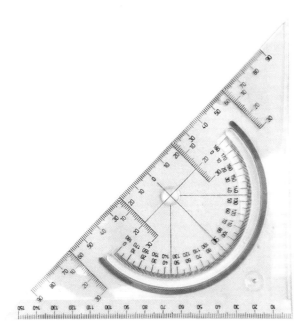

51. Rethink the lollipops

Have fun! Imagine what else you can make out of a lollipop. Draw your ideas.

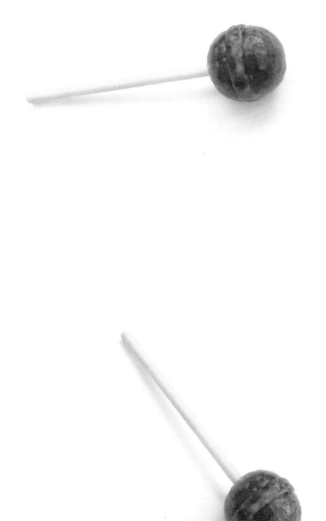

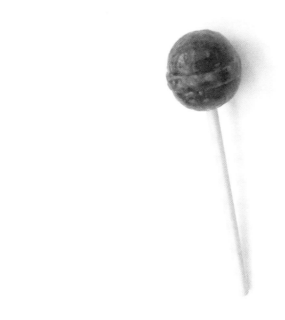

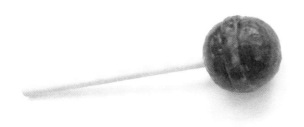

52. Rethink the kazoos

Take a new look at kazoos. What else might they be? Find inspiration in the shape. Draw your thoughts by adding to the kazoos.

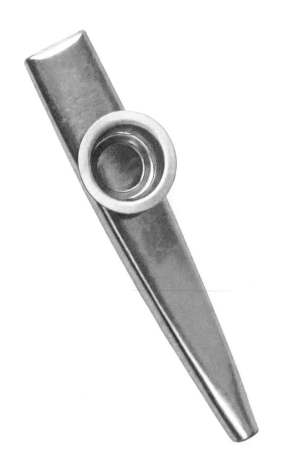

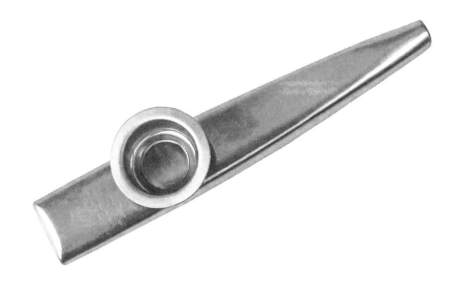
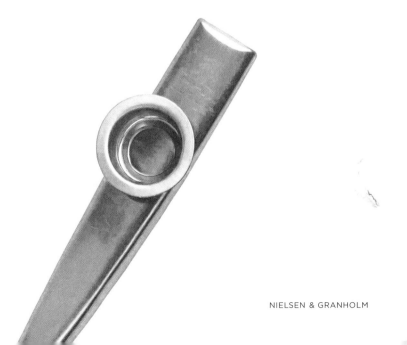

About the authors

Dorte Nielsen

Dorte Nielsen, M.Sc., is a creativity expert, author and keynote speaker. She is the founder of Center for Creative Thinking and the brand Creative Thinker. She has dedicated her life to help others become better creative thinkers. She was educated at The Graphic Arts Institute of Denmark, The School of Communication Arts in London, and holds a Master of Science in Creativity from the ICSC, New York.

After her advertising career in London, she has been teaching and researching creativity. She founded an award-winning bachelor degree programme for conceptual thinkers. After her success in training creativity at the university level, Dorte took her uniquely effective creativity curriculum to primary schools.

Dorte Nielsen is the author of 10 books and 2 games. Her books are published in 11 languages and are sold in 65 countries. In 2020 she received the Alumni Achievement Award by The International Center for Studies in Creativity, New York and the Creative Achievement Award by Creative Circle for her contributions to the field of creativity.

Katrine Granholm

Katrine Granholm, M.F.A. is a digital artist, lecturer, and concept creator. She holds a BA in Graphic Art from the Graphic Arts Institute of Denmark and a Master of Fine Art from London University of the Arts, from which she graduated with distinction in 2013. Her interactive installations have been exhibited in both England and Denmark.

From 2007 to 2015 Katrine Granholm worked as a full-time lecturer teaching concept making alongside Dorte Nielsen. Later she returned to advertiseng to works as a Creative Director.

Since 2019 she has held the position of Digital Commissioning Editor for Children at the DR (The Danish Broadcast Corporation).

Katrine Granholm has authored sevelral books about creativity, created digital tools and conceptual art.

Authors Dorte Nielsen and Katrine Granholm – Photo by Irina Boarsma

Have more fun!

The exercises and activities in this book are based on a solid theoretical foundation, creativity research and neuroscience.

If you would like to know more about the theory and the thinking behind the exercises we can recommend the book:*"The Secret of the Highly Creative Thinker. How to make connections others don't"* by Dorte Nielsen and Sarah Thurber.

If you would like even more exercises we recommend

"Creative Thinker's Exercise Book" by Dorte Nielsen and Katrine Granholm. It's designed for adults and visual thinkers.

If you are in love with this book and want even more fun why not try something completely different - our fun games designed to enhance your ability to make connections:

"Little Creative Thinker's Connection Dominoes" and "Creative Thinker's Connection Memory Game" by Dorte Nielsen and Katrine Granholm.

creativethinker.com